Let's Look at Pictures
by Christine Walkling

THE MEDICI SOCIETY LTD
LONDON 1976

Giotto di Bondone (c.1266–1337)

Giotto was one of the most important artists in the history of European painting for he was the first painter for hundreds of years who made his pictures lifelike. The Byzantine artists before Giotto painted rather stiff, formal pictures which were made only to help people to pray. They were not interested in showing the world as it really was and although Giotto learnt much from their often beautiful paintings he abandoned their style for a new realism in his own works.

Giotto was born in a small village near Florence in about 1266. He was probably taught to paint by the famous Florentine painter, Cimabue, who according to legend 'discovered' Giotto when, as a shepherd boy, he was drawing a sheep on a rock.

Giotto's first important task was probably the wall paintings which tell the Life of St. Francis in the Church of St. Francis at Assisi. In Giotto's time the best way of teaching people the stories of the Bible and the lives of the saints was to paint scenes on the walls of churches. These paintings, called frescoes, had to be painted onto freshly prepared plaster. The artist had to work quickly while the plaster was still

1. Margarito of Arezzo *The Virgin and Child in Glory*, 13th century. National Gallery, London.

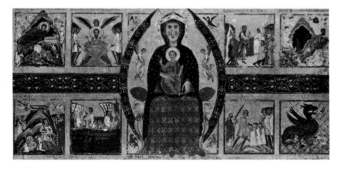

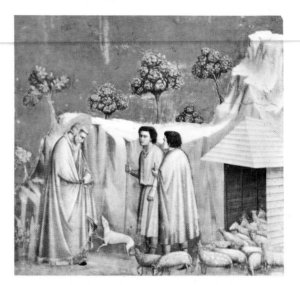

2. Giotto *Joachim Comes to the Sheepfold*, c.1304–6. Arena Chapel, Padua.

wet, for the colour actually soaked into the surface. A mistake would mean scraping off the plaster and starting all over again.

Giotto's greatest work is the series of frescoes covering the walls of the Arena Chapel in Padua which tell the story of the Life of the Virgin Mary, her parents Joachim and Anna, and Jesus Christ. These scenes show us clearly that Giotto was trying to paint things as he saw them. In no. 3 *(Christ's Entry into Jerusalem)* the people look solid and they occupy space in the painting just as they would in real life. In the Byzantine picture (no. 1) however, the figures are flat and do not have any depth – they seem to float in mid-air rather than stand firmly on the ground.

Giotto rediscovered how to give depth to buildings by using perspective. He made the lines of the top and bottom of a wall come closer together as the wall goes further back into the picture, just as when you look down a railway line the rails appear to come

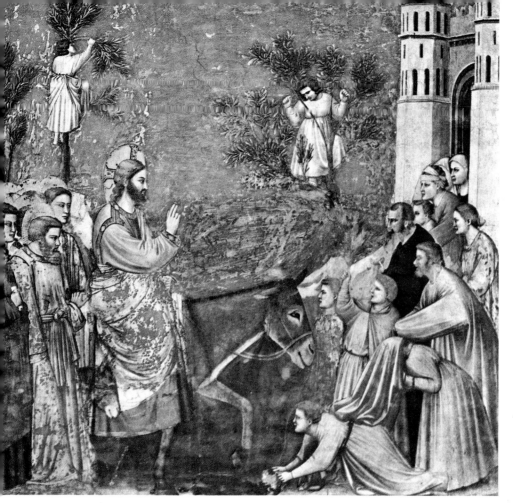

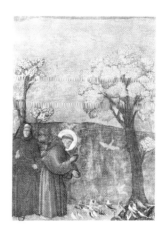

4. Giotto *St. Francis Preaching to the Birds*, c.1300. Upper Church of St. Francis, Assisi. St. Francis is seen in the action by which we best remember him – preaching to the birds. As was common at the time, Giotto was probably much helped by assistants in the frescoes at Assisi. Sometimes it is difficult to tell who actually painted very early pictures.

closer together as they disappear into the distance. You will see how he has done this if you place rulers along the top and bottom of the wall of the hut in no. 2. In showing depth and distance, Giotto had to trust to his own eye, for the laws of perspective were not worked out until nearly 100 years later, during the Renaissance, the great 'rebirth', of Italian art. Giotto paved the way for the Renaissance by making the things in his pictures look real.

3. Giotto *Christ's Entry into Jerusalem*, c.1304–6. Arena Chapel, Padua. Christ rides triumphantly into Jerusalem on a donkey, while two boys break off palm leaves to strew on the ground and a man takes off his cloak to lay down before Him. At the gates of the city a crowd greets Him, the same people who will soon demand His death. Giotto uses the composition of the picture to emphasise the rift that is to come between Christ and his apostles on one side, and the crowd on the other side of the picture.

Jan van Eyck (c.1390–1441)

While Italian artists were discovering scientific ways to make their pictures look real (see p. 6), van Eyck trusted to his eyes and painted what he saw with such accuracy that we almost feel we could reach out and touch the fur on a cloak or the velvet of a dress.

Van Eyck was born in the Netherlands when artists were painting beautiful, decorative pictures like the page from an illuminated book in no. 5. The artists wanted above all to make the figures look elegant and fashionable so they have made them taller and thinner than they really could have been. The background, with its 'fairy-tale' castle, is flat and looks rather like a tapestry. In van Eyck's portrait (no. 8) the room and the people look so real that we could almost walk in and speak to them. Van Eyck has created a wonderful feeling of space, light and air in the picture and has made his figures look solid and rounded. He has also made the surface of different things more lifelike than any artist had done before, from the soft fur on the robes to the hard, shiny metal of the chandelier reflecting the light. Van Eyck shows us accurately how the sunlight streams through a window and falls across the room. In his revolutionary use of light he looked forward to the seventeenth-century Dutch painters like Vermeer (see p. 14).

To help him do so many new things in painting, van Eyck perfected the technique of oil painting. Most artists before him used tempera–they mixed their colour with egg yolk to bind it. As tempera dried quickly they had to work with speed but van Eyck found that if the colours were mixed with oil, probably linseed oil or nut oil, the paint stayed soft for much longer. He used this technique to apply thin layers of oil paint over a white ground which he gradually built up to give the effect of light shining through the colours.

Despite his genius, van Eyck's influence was rather limited at first and it was a fellow artist, Roger van der Weyden, who with his less realistic but more elegant and expressive figures (see no. 6) had the greater influence on the young artists of the Netherlands.

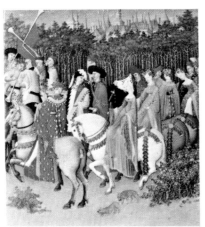

5. Limbourg Brothers *May: A Cavalcade*, from *Les Très Riches Heures du Duc de Berry*, c.1410–16. Musée Condé, Chantilly.

6. Van der Weyden *Adoration of the Kings*, c.1460. Alte Pinakothek, Munich.

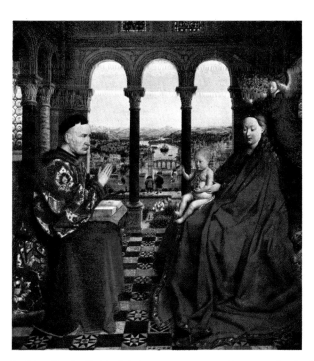

7. Van Eyck *Rolin Madonna*, c.1434–5. Louvre, Paris. This picture of the Madonna and Child with Nicholas Rolin, Chancellor of Burgundy, is particularly well known for the realistic landscape in the background. Van Eyck was one of the first European painters to see that objects look not only smaller but less clear as they disappear into a misty haze in the distance.

8. Van Eyck *Arnolfini Wedding Portrait*, 1434. National Gallery, London. This portrait was painted to celebrate the marriage of an Italian couple, Giovanni Arnolfini and Giovanna Cenami, in 1434. Arnolfini is just about to place his right hand into hers as a sign of their marriage. The picture is full of other symbols – the single candle in the chandelier is a sign of God's presence; the girl wears green, the colour for affection; and even her lively little dog is a sign of her faithfulness. The mirror reflects the back of the couple and shows two men standing as witnesses in the doorway. One of them is probably van Eyck himself for on the wall he has written 'Johannes de Eyck fuit hic' ('Jan van Eyck was here').

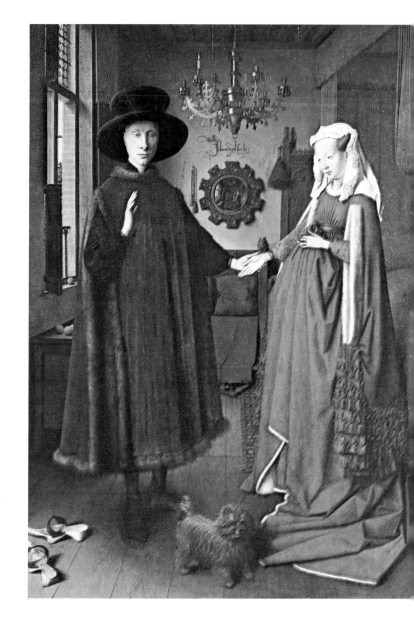

Sandro Botticelli (c.1445–1510)

While van Eyck and van der Weyden were laying the foundations of painting in northern Europe, in the south the Italians were entering the period of the Renaissance. From the time of Giotto, Italian people, especially in Botticelli's home town of Florence, had become fascinated by the civilizations of the Ancient Greeks and Romans which they were discovering more than 1,000 years later. Inspired by the realistic Greek and Roman sculptures the artists of the Renaissance began to make exciting new discoveries which helped them make things look more real in their paintings. If we look at no. 9 we can see how the carefully worked out lines of the floor, the ceiling and the walls all lead to a single 'vanishing' point. This way of creating depth and distance is called mathematical perspective. The artists also learnt anatomy so that they could draw the human body correctly and they studied nature so that they could paint realistic landscapes.

Botticelli learnt about these discoveries but he did not always use them because, unlike other artists at the time, he did not always want to copy nature. In

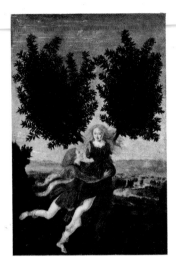
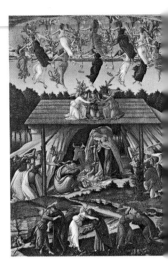

10. Pollaiuolo *Apollo and Daphne*, c.1480. National Gallery, London.

11. Botticelli *Mystic Nativity*, 1500–1. National Gallery, London. In this picture Botticelli has focused our attention on the most important characters, the Holy Family, by deliberately making them much bigger than any of the other figures. We would normally expect the largest figures to be those in the foreground of the picture.

fact he sometimes purposely distorted reality so that he could express his feelings of joy, love, grief, or beauty. In *The Birth of Venus* (no. 12), one of his most famous and beautiful paintings, Botticelli has used pure, flowing lines to create the lovely figure of Venus. To make her even more graceful he has made her neck longer than it could really have been and to avoid breaking the line of her body he has made her shoulders slope in a way that is impossible. Botticelli has not even tried to paint a real-looking landscape in the background of the picture–the 'tongues' of land which go back into the distance are simply part of the pattern–they echo the rippling lines of the cloak which Hora, one of the seasons,

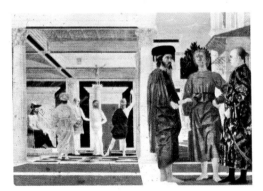

9. Piero della Francesca *Flagellation*, c.1456. Galleria Nazionale delle Marche, Urbino.

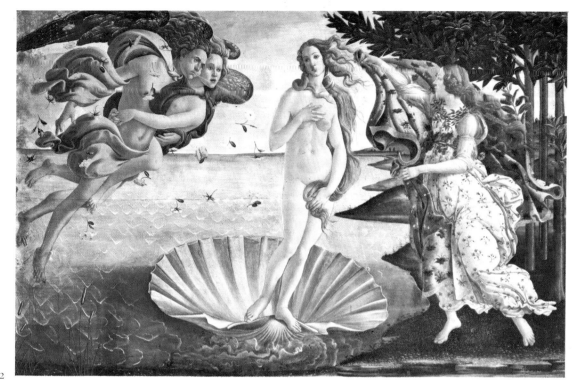

12

holds ready to wrap around Venus. By making the outlines of things so important Botticelli, like Pollaiuolo (see no. 10), was able to create the most wonderful effect of movement. We can almost feel the breeze from the two zephyrs (wind-gods) who rush with billowing draperies to blow Venus to the shore.

The *Mystic Nativity* (see no. 11) shows the intense religious feeling of Botticelli's later years when there were serious political and religious troubles in Florence. The picture is full of religious symbols, for instance as a sign of 'Peace on Earth' the angels carry olive branches and the kings and shepherds wear wreaths of olive leaves. The circle of angels over the

stable dance with ecstatic joy at the birth of Jesus. Eventually Botticelli's emotional style came to be thought of as old-fashioned and even before he died a new, grand style in painting was being created by Leonardo, Michelangelo and Raphael.

12. Botticelli *The Birth of Venus*, c.1485. Uffizi Gallery, Florence. This painting illustrates the Ancient Greek story of how Venus, the beautiful Goddess of Love, was born from the foam of the sea and blown by zephyrs to the island of Cyprus. The picture was painted for a member of the wealthy and powerful Medici family who were great patrons of the arts in Florence.

Leonardo da Vinci (1452–1519)

Leonardo was not only a brilliant painter, sculptor and architect but also one of the most important scientists of his day and a skilled engineer. Throughout his many notebooks we find fascinating glimpses of ideas for inventions, like submarines and helicopters, which were not carried out for hundreds of years. Because of his many different interests he left only a few paintings.

Born in Florence, Leonardo began as an apprentice to the painter and sculptor, Verrocchio, who was so impressed by the great beauty of his pupil's painting that it is said he vowed never to paint again. From his earliest pictures we can see that Leonardo was more passionately interested in nature than any artist before him. He made thousands of drawings of plants, rock formations, flowers, and even the actual folds of drapery so that he could paint all these things correctly in his pictures.

Leonardo created a completely new style that was noble, solemn and dignified. If we look at the beautiful *Virgin of the Rocks* (no. 16) we can see how he used

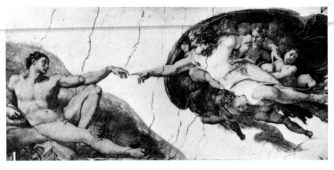

14. Michelangelo *Creation of Man*, 1510–12. Sistine Chapel, Rome. By courtesy of the Vatican Museums.

the composition of the picture to create a feeling of quiet dignity–the figures of the Virgin, Jesus, St. John the Baptist and the Angel make a perfectly balanced pyramid or triangle. This simple composition gives a feeling of great stability. There is no restless movement like we see in some of Botticelli's pictures and nothing distracts our eye from the closely knit unity of the figures. No. 13 shows how Raphael was influenced by Leonardo's pyramidal composition.

Leonardo used light and shade in a completely new way. In the *Virgin of the Rocks* we can see that instead of using hard outlines to paint his figures, like Pollaiuolo or Botticelli (see pp. 6 and 7), Leonardo softened or 'smudged' the outline so that the light parts gradually merge into the shadow. This technique, called 'sfumato' (meaning smoky or misty), makes the figures look much more realistic than the rather stiff, wooden figures in the earlier part of the Renaissance.

Leonardo paved the way for the grand style of two younger artists, Michelangelo and Raphael, who created some of their greatest works in Rome. No. 14 shows part of the famous ceiling Michelangelo painted in the Sistine Chapel. In this dramatic and moving moment, God the Father brings Adam to

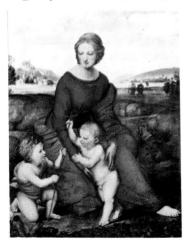

13. Raphael *Madonna in the Meadow*, 1505. Kunsthistorisches Museum, Vienna.

life with a touch of his finger. The figure of Adam is one of the most noble and beautiful human bodies created since the sculptures of Ancient Greece and Rome. No wonder the men of the time felt that with the genius of Leonardo, Michelangelo and Raphael they had at last recaptured the glory of the Ancient World.

16. Leonardo *Virgin of the Rocks*, c.1506. National Gallery, London. This is a later version of a very similar painting now hanging in the Louvre in Paris. The earlier picture was commissioned in 1483 by the Confraternity of the Immaculate Conception in Milan, but it was the later version which was eventually placed in the chapel of the Confraternity in 1506. It seems particularly strange that Leonardo painted two versions of the same picture when he completed so few paintings. The background of the picture shows Leonardo's love of mysterious, rocky landscapes—he was fascinated by the dramatic side of nature and made many drawings of storms, floods and whirlpools.

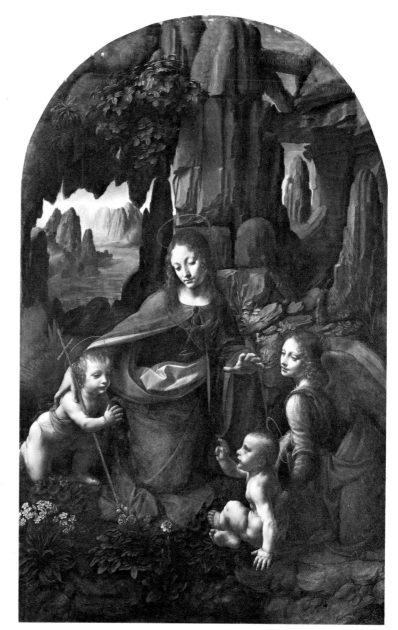

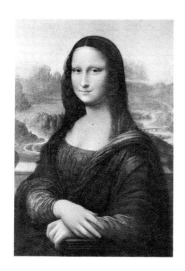

15. Leonardo *Mona Lisa, c. 1502.* Louvre, Paris. In the *Mona Lisa*, probably the most famous portrait in the world, Leonardo has left the corners of the sitter's eyes and mouth in shadow so that we cannot quite see her expression. By making us use our imagination to 'fill in' the expression for ourselves, Leonardo has made her look so alive that her eyes seem to follow us around the gallery where her portrait hangs, and each time we look, her expression seems different.

Titian (c.1487–1576)

When Leonardo was creating his masterpieces, a completely different style of painting was growing up in Venice. The Venetian painters created pictures to match the beauty of their island city with its splendid palaces and churches and romantic canals. They bathed their pictures in light and loved to use rich glowing colour.

The most famous and successful of the Venetian painters was Titian. What immediately strikes us about his *Bacchus and Ariadne* is the beautiful colour, the vivid blue of the sky, the rich pinks and golden yellows, and the feeling that light and air surround Bacchus and his followers. Titian has created a wonderful feeling of movement and energy in the composition. Bacchus leaps from his chariot, behind him a figure swings his arms to make the cymbals clash and all the figures look as if they are rushing

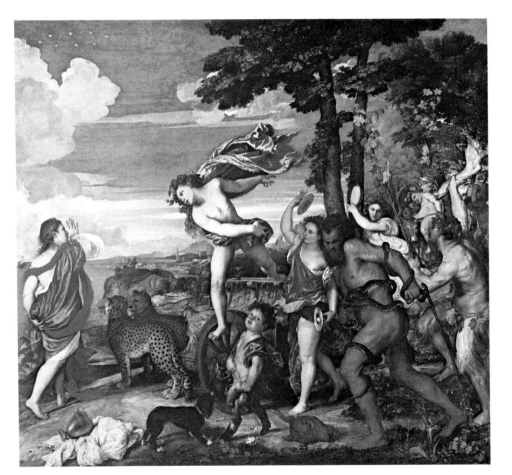

17. Titian *Bacchus and Ariadne*, 1523. National Gallery, London. This is one of a set of pictures painted for Alfonso d'Este, Duke of Ferrara. Like the educated people of Florence, the Venetians were very interested in the stories of the Ancient Greeks. Titian's picture shows Bacchus, the God of Wine, coming upon the startled Ariadne, who was the daughter of Minos, King of Crete. Having been abandoned on the island of Naxos, Ariadne is rescued by Bacchus who falls in love and marries her. After Ariadne's death, Bacchus set their wedding crown in the sky as a group of eight stars called 'Corona Borealis'. We can see these stars in the top, left hand corner of the picture.

from the right side to the left, except for Ariadne who stops in startled surprise.

Titian was taught to paint by Giovanni Bellini, the first great Venetian painter, but he learnt even more from an older pupil of Bellini's, Giorgione, who was one of the first artists to put the figures in his paintings right into the landscape, surrounded by grass and bushes (see no. 18). Titian has followed his example in *Bacchus and Ariadne*. The landscape is not just a background for the figures as it was in Leonardo's *Virgin of the Rocks*, but the figures are in the landscape itself. The happy, riotous throng tumble down a hillock from the woods into a clearing with a view that goes right back along the seashore.

Titian was one of the greatest portrait painters who ever lived. Kings, popes and great noblemen from all over Europe competed to have their portraits painted by him. No. 19 shows the victorious Emperor Charles V seated on the black charger which he rode at the Battle of Mühlberg. Contrast the bold brushwork and dramatic style of this portrait with the careful attention to detail in *The Merchant George Gisze* (no. 20) by the great German artist, Holbein. A contemporary of Titian, Holbein spent many years at the English Court and left us a fascinating record of King Henry VIII and his courtiers.

By the time Titian reached old age, a new generation of artists like Tintoretto were receiving the important commissions. Titian was left free to paint as he liked and in his late masterpieces he used thick patches of colour applied with broad, free brushstrokes to express his feeling about the subject. It is interesting to see that later Rembrandt used a similar 'free' style to express his feelings when he became an old man (see p. 12).

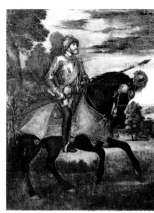

18. Giorgione *The Tempest*, c. 1508. Galleria dell' Accademia, Venice.

19. Titian *The Emperor Charles V on Horseback*, 1548. Prado, Madrid. This magnificent equestrian portrait influenced several future artists including Velasquez and Rubens. The Emperor Charles V admired Titian so much that he made him his Court Painter and they became personal friends, an unusual honour for a painter at that time.

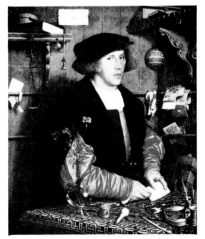

20. Holbein *The Merchant George Gisze*, 1532. Staatliche Museen, Berlin.

Rembrandt van Ryn (1606–1669)

As a young man Rembrandt moved from his home town of Leiden to the busy city of Amsterdam where he soon enjoyed great success and popularity with his portraits of the wealthy burghers. He married a rich, young girl called Saskia and for the next few years they led a very happy and prosperous life. Sadly, Rembrandt's good fortune did not last. His popularity waned when a more flattering style of portraiture came into fashion with the influence of the Flemish painter, van Dyck. But much worse was the tragically early death of his beloved Saskia. From then on Rembrandt became more interested in man's inner life than his outward appearance and his portraits and biblical scenes show a great sympathy and understanding for people.

One of the most striking things about Rembrandt's painting is his use of light and shade. If we look at the *Nativity* (no. 21) our eyes are directed immediately to the Holy Family because of the soft, glowing light which makes them stand out from the darkness of the stable. In the *Man in Armour* (no. 22) Rembrandt has used light and shade in a more subtle way to give the picture a touch of mystery. He has made the shadow of the young soldier's helmet hide his eyes so that we can only guess his expression. The strange helmet with its decoration of an owl's head shows Rembrandt's love of exotic costumes and props and the deep, warm reds and browns and the golden yellows are typical of the rich colour he used, particularly in his later works. The great Flemish painter, Rubens, who lived at the same time as Rembrandt preferred to use brighter, clearer colours and in *Le Chapeau de Paille* (no. 23) he has painted the model in direct sunlight which contrasts with the deep, mysterious shadows and supernatural light in Rembrandt's pictures.

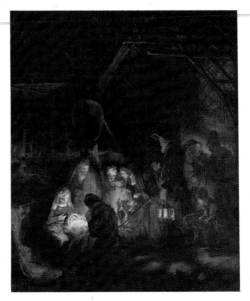

21. Rembrandt *Nativity*, 1646. National Gallery, London.

The *Man in Armour* was painted when Rembrandt was beginning to suffer severe poverty. He only avoided bankruptcy by being 'employed' by his son Titus and his devoted housekeeper and friend, Hendrickje Stoffels. But Rembrandt reached the height of his artistic powers during these years. The wonderful portrait of an old man (see no. 24), painted in a very 'free' style, shows a depth of tender feeling and compassion which few other artists ever reached.

22. Rembrandt *Man in Armour*, c.1655. Glasgow Art Gallery. The *Man in Armour* originally showed only the head of the man, but later four pieces were stuck on to make it into a half-length figure. We do not know who the figure represents. Some people think he is Rembrandt's son, Titus, others have suggested Apollo or Mars, the God of War, or it may be the lost picture of Alexander the Great, which Rembrandt painted for an Italian art collector. Perhaps the most likely explanation is that Rembrandt simply made the subject up out of his own imagination.

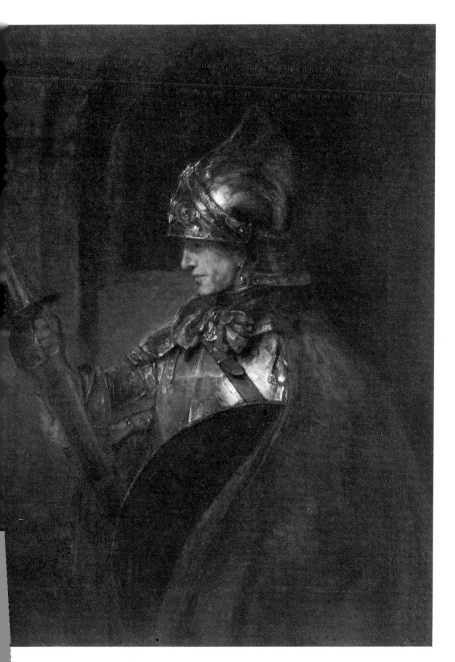

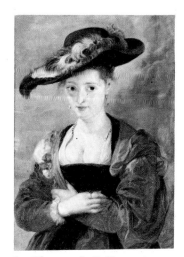

23. Rubens *Le Chapeau de Paille*, c.1622–5. National Gallery, London.

24. Rembrandt *Old Man in an Armchair*, 1652. National Gallery, London. This old man probably came from the poor district of Amsterdam where Rembrandt himself later settled. Rembrandt's portraits include many compassionate studies of old people.

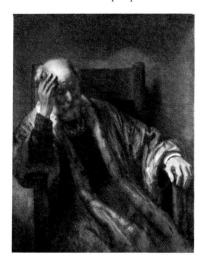

Jan Vermeer (1632–1675)

Vermeer was born when Rembrandt was 26. Holland was enjoying a time of great peace and prosperity when more and more people wanted to hang pictures in their homes. By the time Vermeer grew up most people were finding Rembrandt's paintings too difficult to understand. They wanted to buy small pictures of the familiar things they saw around them, still-lifes, landscapes, sailing boats, and genre scenes like those Vermeer painted showing people doing some everyday task or playing musical instruments (see no. 28). Other painters like Jan Steen painted similar subjects but his scenes are lively and full of movement (see no. 26) while Vermeer's are quiet and poetic. Vermeer transformed his everyday scenes into some of the most beautiful pictures ever created.

If we look at *The Music Lesson* (no. 28) we can see how Vermeer was fascinated by the effect of light filtering through the windows and shining on the figures and objects. The light reflected from the rug in the foreground seems almost to dissolve the detail of the pattern, just as it does when the sunlight shines on a patterned carpet in your own house. In *The Lacemaker* (no. 27) Vermeer shows us how light affects different textures in different ways—the skin of the girl glows with softness and warmth, the polished wood shines brightly and the embroidery silks spilling from the cushion sparkle like jewels.

27. Vermeer *The Lacemaker*, c.1665. Louvre, Paris. In *The Lacemaker* Vermeer has created a beautiful design of curving shapes which flow into each other, for instance the lines on the cushion are carried on along the girl's sleeve. The straight lines of the table form a striking contrast. Our eyes are focused on the steady concentration of the girl's face and the lovely pattern of her fingers which so intricately work the lace.

25. Velasquez *Las Meninas*, 1656. Prado, Madrid.

26. Steen *Poultry Yard*, 1660. Mauritshuis, The Hague.

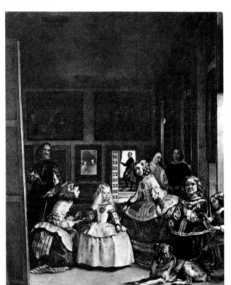

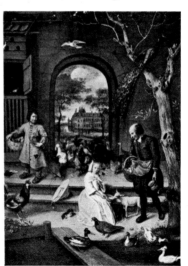

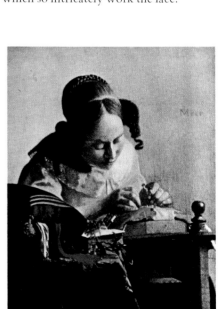

Like many other artists of his time Vermeer was interested in the mysterious effects created by mirrors—in *The Music Lesson* the tilted mirror reflecting the girl's face shows the strange pattern objects make when seen from an unusual angle. In *Las Meninas* (no. 25), painted about ten years earlier by the great Spanish artist, Velasquez, the whole subject is made confused and mysterious by the introduction of a mirror on the far wall which reflects the Spanish King and Queen. Velasquez himself stands at a large easel on the left—is he painting a portrait of the King and Queen? or is he painting their daughter, the little Infanta, and her retinue who are perhaps reflected in a huge mirror into which they are all looking?

The light, airy room in *The Music Lesson* is very different from the shadowy interiors of Rembrandt's paintings. Vermeer thought of the space in his pictures as an empty box with the lines of the room clearly shown. The striking vertical and horizontal lines of objects like the window frames, the virginals and the mirror make a strong and balanced composition which is as interesting as the figures, who seem mysteriously remote, partly because of the objects Vermeer has placed in front of them. Most of the figures in Vermeer's pictures are engrossed in their own thoughts—we are kept at a distance and not allowed to enter their private world.

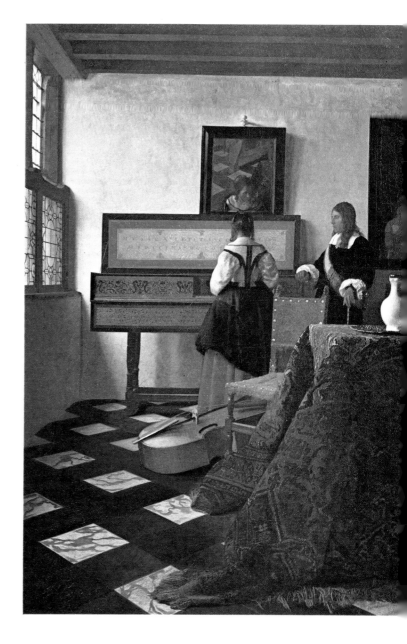

28. Vermeer *The Music Lesson*, c.1665–70. Reproduced by gracious permission of Her Majesty the Queen. This painting probably shows Vermeer's own studio. The perspective in the picture is particularly interesting for it is rather steep. Some people think Vermeer painted with the help of a 'camera obscura', a device, like an old-fashioned camera, which projected the image through a lens on to a piece of paper. The artist then painted from this image, the lens making the perspective look steeper than it would normally appear.

Jean Antoine Watteau (1684–1721)

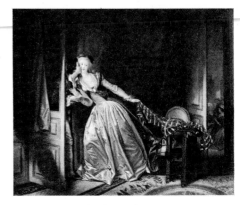

30. Fragonard *The Stolen Kiss*, c.1784. Hermitage, Leningrad.

Vermeer painted people doing ordinary things in their everyday surroundings, but Watteau created a magical dream world in his paintings where beautiful ladies and gallant gentlemen stroll in the woods, listen to music or just sit gazing dreamily at each other. In spite of their pleasure there is a touch of sadness as though things cannot last forever. Watteau probably knew that his own life would be short for he suffered from consumption at an early age and died when he was only 37.

Before Watteau, French art was rather solemn and grandiose to suit the taste of the powerful, stately 'Sun King', Louis XIV. The most important influence in painting was the great classical artist, Nicolas Poussin, whose style can be seen in the tightly constructed composition of *Landscape in the Roman Campagna* (no. 29), which is based on a series of vertical, horizontal and diagonal lines. If we look at *The Music Party* (no. 32) we can see that Watteau painted in a completely different style with the groups of figures making a pattern of graceful flowing curves instead of straight lines. Poussin thought that colour was not very important but Watteau loved colour and painted his figures in richly coloured silks with silvery light shimmering on them. The elegant, light-hearted atmosphere of *The Music Party* perfectly matched the mood of the French courtiers who longed for pleasure and gaiety after the extremely dignified but boring life at the Court of Louis and his pious wife, Madame de Maintenon.

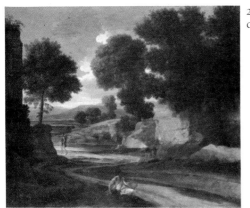

29. Poussin *Landscape in the Roman Campagna*, c.1644–6. National Gallery, London.

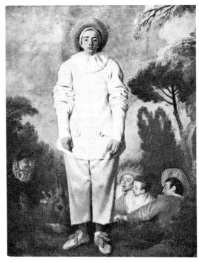

31. Watteau *Gilles*, c.1719. Louvre, Paris. *Gilles* may have been painted as a billboard for a performance of the Italian theatre company, the Comédie-Italienne. The sad-funny figure of Gilles, better known as Pierrot, is accompanied by other popular characters from the Comédie-Italienne, Cassandro, Leandro, Isabella and a dandy.

Soon after Watteau settled in Paris he began to work with Claude Gillot, an artist whose pictures of the theatre had a lasting influence on him. In *The Music Party*, for instance, the figures look as if they are on a stage framed by the tall columns on either side, and the background looks rather like stage scenery. Watteau obviously loved the theatre and many of his pictures (see no. 31) show actors and actresses from the companies of Italian and French comedians (the Comédie-Italienne and the Comédie-Francaise) whose brilliantly funny performances were very popular in France.

Watteau always carried a sketchbook with him and his many hundreds of beautiful drawings leave us a fascinating record of the costumes people wore, their manners and the way they used to sit, stand or dance. When he came to paint a picture he would choose certain figures from his sketches and arrange them to make a group in the painting.

Watteau's influence on French art was enormous. His pictures so suited the gay, frivolous atmosphere of the eighteenth century that artists like Fragonard (see no. 30) painted in a similar style right up until the French Revolution (1789) when art became once again solemn and classical.

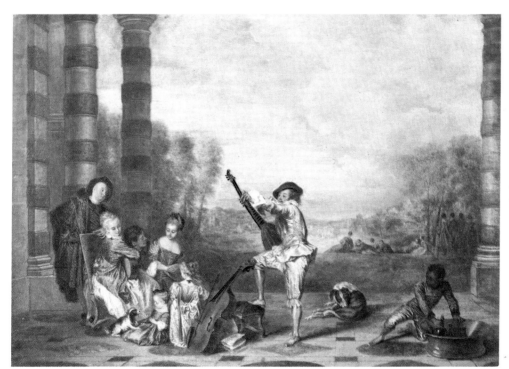

32. Watteau *The Music Party*, c.1718. Reproduced by permission of the Trustees of the Wallace Collection, London. The musician strums a lute while the lady on left softly plays a guitar. A viola d'amore stands propped up against the stool. Watteau would have had many opportunities to see musicians for one of his most important patrons, Pierre Crozat, passionately loved music and Watteau would spend hours sketching at the music parties which Crozat often held to entertain his friends. Crozat had a wonderful art collection which Watteau was able to study. He was particularly impressed by the rich colour and lively composition of Titian (see p. 10) and Rubens, whose influences can both be seen in this beautiful picture.

John Constable (1776–1837)

Whereas Watteau created a fantasy world, Constable painted the 'real' world of the English countryside with its dewy fields and fresh, windy skies. Most people in England were not ready to appreciate Constable in his lifetime, partly because they were not used to the very bright greens and yellows with which he truthfully painted nature. Also, the influential Royal Academy thought the subject of his pictures inferior to 'history painting' (mythological and biblical scenes) and they reluctantly accepted him as a Royal Academician only a few years before he died.

The son of a prosperous miller, Constable was born in East Bergholt, Suffolk. Even as a boy he loved the countryside around his home and later painted it in his most famous pictures including *The Cornfield* (no. 36). He passionately believed in truth to nature and would spend hours in the open air drawing trees, fields and rivers. Particularly fascinated by the ever-changing sky, he made many studies of clouds,

33. Gainsborough *Mr and Mrs Andrews*, c.1750. National Gallery, London

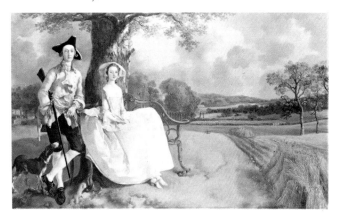

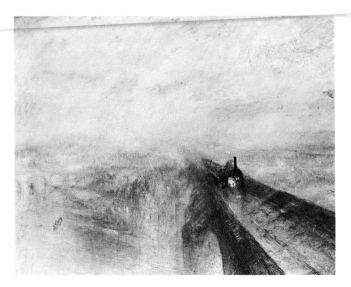

34. Turner *Rain, Steam and Speed*, Exhibited 1844. National Gallery, London.

fluffy and white on a summer's day or black and threatening with a coming storm. In *The Cornfield* we can see how he used this wealth of observation to create a true picture of the English countryside—the sparkling sunlight flickers through the trees which gently sway in the breeze and in the distance the light makes pools of bright colour where it breaks through the moving clouds.

Constable always preferred 'home scenery' to the dramatic landscapes and seascapes of England's other great landscape painter, Turner, who loved storms, blizzards and extraordinary lighting effects where the forms are almost dissolved in a shimmering golden haze (see no. 34).

Although nature itself was his most important inspiration, Constable was influenced by the landscapes of earlier artists, including Gainsborough (see no. 33), Claude Lorraine and Nicolas Poussin.

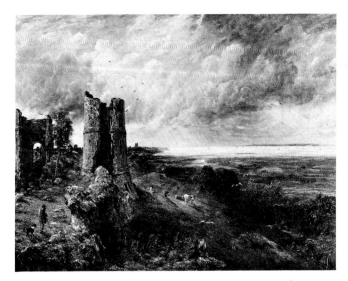

35. Constable *Hadleigh Castle*, c.1829. Collection of Mr and Mrs Paul Mellon. When he visited Hadleigh in 1814 Constable wrote to Maria Bicknell saying how impressed he was by the 'melancholy grandeur' of the seashore. He drew a small sketch of the castle but it was not until soon after Maria's death that he used the drawing to paint this powerful picture.

If we compare Poussin's picture on p. 16 with *The Cornfield* we can see how in both paintings there are paths or edges of fields which make a series of diagonal lines—our eye follows these lines from side to side until we are led gradually into the far distance.

From 1816, the year of his marriage to Maria Bicknell, Constable enjoyed a period of great happiness, painting some of his finest works and enjoying considerable success in France where he was always more popular than in England. Unfortunately this time of happiness came to an end with the tragic death of Maria in 1828. We sense Constable's terrible grief in *Hadleigh Castle* (no. 35) where the dark, brooding sky contrasts with the bright, sunny atmosphere of *The Cornfield*.

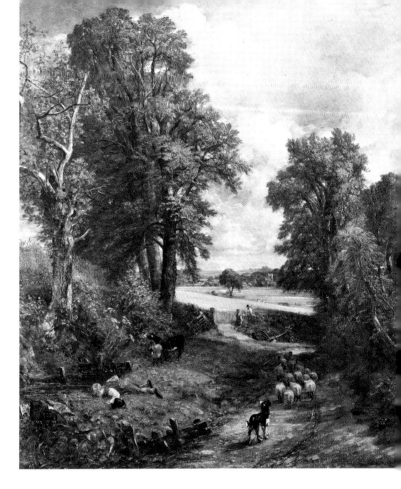

36. Constable *The Cornfield*, 1826. National Gallery, London. This scene shows the lane, leading from East Bergholt Church towards Dedham, which Constable used to walk along every morning to school. It is noon on a hot summer's day and a young boy drinks thirstily from a stream—perhaps Constable remembered doing the same thing himself. To achieve the effect of quivering light on the grass and foliage, Constable has used flecks of white paint—this technique had a considerable influence on French artists including, later, the Impressionists (p. 20). Constable consulted a botanist friend to make sure that he had painted the wild flowers and grasses accurately for the particular time of year.

Pierre Auguste Renoir (1841–1919)

During the later part of the nineteenth century the most exciting centre of the arts was Paris, where Manet shocked the artistic public with his informal, everyday subjects painted in bright, bold colours (see no. 37). Influenced by him a group of young painters including Renoir began one of the most famous movements in art, French Impressionism. Like Constable, they broke away from the 'stuffy' academic art of the past and tried to capture the fleeting light and atmosphere of their surroundings.

If we look at Renoir's *Le Moulin de la Galette* (no. 40) we can see some of the new things the Impressionists were trying to do. First of all, they wanted to paint ordinary people in their everyday surroundings —Renoir loved to paint young people enjoying themselves, dancing, talking and laughing as we see in no. 40. He has captured the fleeting 'impression' of a particular moment when the sunlight shines through the trees and dances in patches of dappled colour,

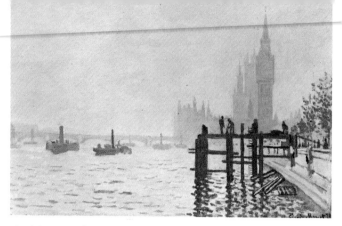

38. Monet *The Thames Below Westminster*, 1871. National Gallery, London. © by S.P.A.D.E.M. Paris, 1975.

giving a wonderful effect of movement which is emphasised by the blurred outlines of the figures. Like the other Impressionists, Renoir preferred to work on the spot rather than in the studio and painted what he saw in front of him without rearranging the figures to make a formal composition.

One of the most striking things about Renoir's picture is the bright colour. To create the effect of

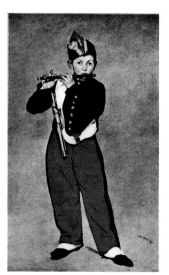

37. Manet *The Fifer*, 1866. Louvre, Paris.

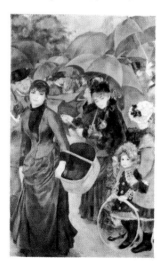

39. Renoir *Les Parapluies* (The Umbrellas), c.1884. National Gallery, London. *Les Parapluies* was painted after a visit to Italy where Renoir was very impressed by the classical style of Raphael (see p. 8). Instead of painting fleeting 'impressions' he began to create more deliberately designed compositions as we can see in the decorative pattern made by the umbrellas which 'frame' the passers-by in this picture.

brilliant sunlight, the Impressionists used the pure colours of the rainbow—violet, indigo, blue, green, yellow, orange and red. By applying broad brush strokes of these pure colours, they achieved a vibrant, sparkling effect which had never been seen before. Later, Seurat took this technique further and made his paintings out of thousands of tiny dots of brilliant colour. Just as light is made up of colours so are shadows—instead of making the shadows in his picture black or brown, Renoir has made them coloured, sometimes blue, sometimes violet or green.

Renoir's fellow painter, Monet (see no. 38) took Impressionism to its logical conclusion by painting several series of pictures to show exactly how the same scene looked at different times as the light changed. But after a few years Renoir himself felt he had fully explored Impressionism and he turned back to a more classical style as we can see in *Les Parapluies* (no. 39) with its more formal design and harder outlines.

Renoir enjoyed a very happy family life and his later pictures often show his lovely, plump wife, Alice, his children and their nurse, Gabrielle. He was still painting just before he died at the age of 78.

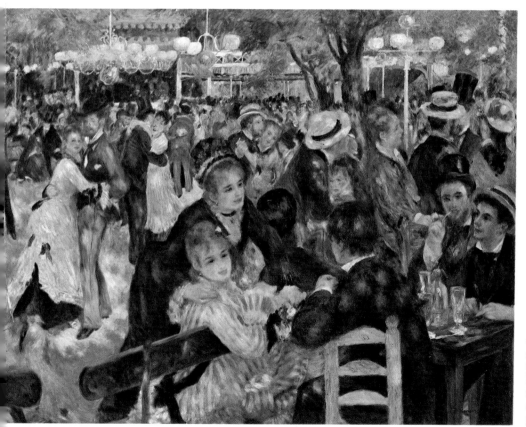

40. Renoir *Le Moulin de la Galette*, 1876. Louvre, Paris. The Moulin de la Galette was a public dance hall in Montmartre, Paris, where whole families would go to spend their Sunday afternoons and evenings. The young people would dance while their parents and younger brothers and sisters sat talking, drinking and eating the galettes (pancakes) which gave the Moulin its name. Renoir liked to go there with his friends and several of them can be recognised in this picture.

Vincent van Gogh (1853–1890)

Van Gogh did not start to paint until he was 27, but during the next ten years until his tragic death he worked in a frenzy creating a huge number of pictures. He had already tried several other careers, finally going as a lay preacher to a poor coalmining district in southern Belgium. Sharing their life of hardship, he gave away everything to the poor but his religious superiors were shocked by his extreme enthusiasm and he was dismissed.

It was after this bitter disappointment that his brother, Theo, persuaded Vincent to take up drawing. His first works, influenced by Rembrandt, show his understanding and deep respect for the workers and peasants whose harsh lives he painted in sombre earthy colours. Gradually he found other less serious subjects and began to paint for the sheer enjoyment of it. In 1886 he went to Paris, where, inspired by the paintings of Renoir and the other Impressionists (see p. 20), he used brighter and brighter colours until he longed to paint in the clear, strong sunlight of the South of France. In 1888 he went south to Arles where he threw himself into his work and painted many of his finest pictures. Arriving in February, he began by painting the delicate pink blossoms of almond and magnolia. But with the strong sunlight of summer came an explosion of bright colour. The picture of sailing boats (no. 44) shows the hazy blue sky of that mid-June when he spent a few days at the

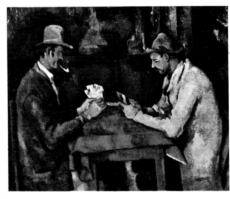

42. Cézanne *The Card Players*, c. 1890–92. Courtauld Institute Galleries, London.

43. Van Gogh *Cornfield and Cypress Trees*, 1889. National Gallery, London. In this picture, painted the year before he died, van Gogh expressed his tormented feelings in the twisting shapes. The corn sways in the wind, clouds swirl across the picture, and the cypress tree reaches upwards like a flame.

41. Gauguin *Fatata Te Miti* (Near the Sea), 1892. National Gallery of Art, Washington (Chester Dale Collection).

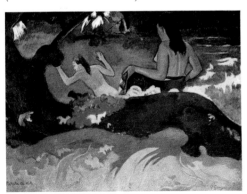

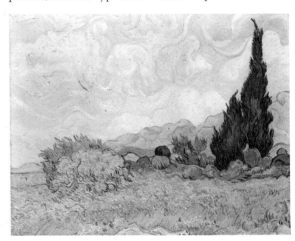

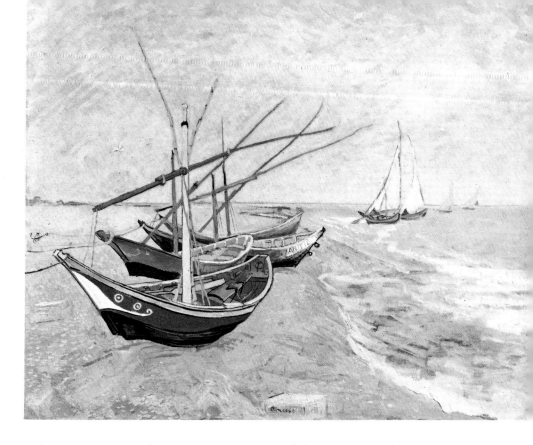

44. Van Gogh *Boats at Saintes-Maries, 1888*. National Museum Vincent van Gogh, Amsterdam. In a letter to his brother Theo, van Gogh tells us how he made a drawing for the painting of these little boats very early in the morning before setting off for his return to Arles. In another letter he describes the red, blue and green boats as being so pretty and brightly coloured that 'one is reminded of flowers'. Each boat would be taken out by one man but if the wind blew even a little hard they would sail straight back for the shore.

seaside town of Les Saintes-Maries-de-la-Mer. Van Gogh wanted his colours to stir our emotions—in this picture the feeling is one of joy in the intense heat and colour of midsummer. The bold shapes of the boats in the foreground show his passionate interest in the shapes of different objects and the striking patterns which they make.

The months in Arles were one of the few happy times in van Gogh's life but in the autumn Gauguin (see no. 41) came to paint with him. They disagreed about almost everything, especially painting. The strain was too much for van Gogh who was working feverishly and he suffered the first of several break-downs. His paintings of this time like *Cornfield and Cypress Trees* (see no. 43) show the restless torment of his mind. Although this picture is strikingly beautiful, there is a feeling of restless anxiety which makes us feel uneasy.

Van Gogh, Gauguin and Cézanne (see no. 42), another great French artist of their time, each had their own very personal way of 'seeing' the objects they painted. Their profound influence helped the artists of the next generation (of whom Picasso is the most famous) to move away from showing recognisable figures and objects in their paintings as artists had done since the time of Giotto.

Index of Artists

Other books you may like to read:
H. W. and D. J. Janson *The Picture History of Painting*, Thames & Hudson, 1957.
E. H. Gombrich *The Story of Art*, Phaidon Press, 1950
Art Treasures of the World, Paul Hamlyn, 1964

The Publishers desire to express their grateful thanks to the Galleries and owners concerned who have kindly allowed their pictures to be reproduced, also to the following, who have kindly co-operated over the supply of photographic material in their possession for the illustrations:
Fama Ltd., London; J. R. Freeman, London; Iris Verlag A. G., Berne; The Mansell Collection, London; The National Gallery, London; Offo, S. L., Madrid; Roberto Hoesch, Milan; Scala, Florence.

Title page illustration: Rembrandt *Rembrandt's Mill*, 1641 (Detail). By courtesy of the Trustees of the British Museum. The etching shows a windmill probably similar to the one Rembrandt's father owned. Etchings are made by drawing with a fine needle on a copper plate from which prints are later taken. Most artists worked in other mediums like etching and drawing as well as painting.

© The Medici Society Ltd., London 1976.
Printed in England at the Medici Press.

SBN 85503 035 6. First published in 1976.